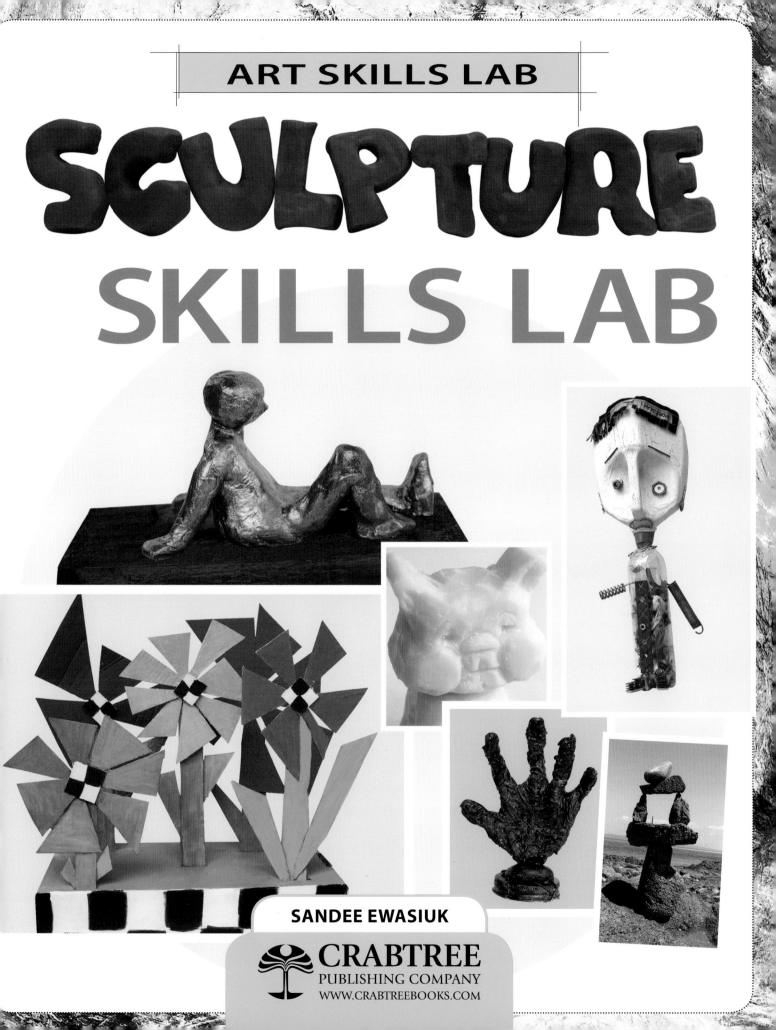

ART SKILLS LAB

SCULPTURE SKILLS LAB

SANDEE EWASIUK

CRABTREE
PUBLISHING COMPANY
WWW.CRABTREEBOOKS.COM

ART SKILLS LAB

Author
Sandee Ewasiuk

Editors
Marcia Abramson,
Kathy Middleton

Photo research
Melissa McClellan

Cover/Interior Design
T.J. Choleva

Proofreader
Crystal Sikkens

**Production coordinator
and Prepress technician**
Tammy McGarr

Print coordinator
Katherine Berti

Developed and produced for
Crabtree Publishing by
BlueApple*Works* Inc.

Consultant
Trevor Hodgson
Fine artist and former director of The
Dundas Valley School of Art

Art & Photographs
Shutterstock.com: © Focus and Blur (cover middle left); © tescha555 (cover bottom left); © Photo Love (cover top right); © Excellent backgrounds (background); © Refat (p. 4 left); © Yuliia Myroniuk (p. 4 right); © QQ7 (p. 5 top right); © Joyce Nelson (p. 5 top left); © James Kirkikis (p. 5 bottom left); © Baylor de los Reyes (p. 5 bottom right); © Winai Tepsuttinun (p. 6 bottom left); © Yulia elf_inc Tropina (p. 6 top middle); © Maksym Bondarchuk (p. 6 top right); © Ilike (p. 6 bottom); © PM8899 (p. 7 top); © aaabbbccc (p. 13 bottom right); © Electric Egg (p. 15 bottom right); © melissamn (p. 17 bottom right); © kavalenkau (p. 21 top right); © Thomas Barrat (p.23 bottom right);

© Austen Photography (cover, title page, TOC, p. 7– 29)

Instructive sculptures © Sandee Ewasiuk cover, p. 7– 29 excluding bios

p. 5 middle right: The Harry G. C. Packard Collection of Asian Art, Gift of Harry G. C. Packard, and Purchase, Fletcher, Rogers, Harris Brisbane Dick, and Louis V. Bell Funds, Joseph Pulitzer Bequest, and The Annenberg Fund Inc. Gift, 1975. Metropolitan Museum of Art
p. 9 bottom left Public Domain
p. 9 bottom right Stephencdickson/ Creative Commons
p. 11 top right Ansgar Walk/Creative Commons
p. 19 right Gift of J. Pierpont Morgan, 1917. Metropolitan Museum of Art
p. 27 bottom right World History Archive/ Alamy Stock Photo
p. 29 top right Ham/Creative Commons
p. 29 bottom right picman2 from Pixabay

Library and Archives Canada Cataloguing in Publication

Title: Sculpture skills lab / Sandee Ewasiuk.
Names: Ewasiuk, Sandee, author.
Series: Art skills lab.
Description: Series statement: Art skills lab | Includes index.
Identifiers: Canadiana (print) 20190231831 |
 Canadiana (ebook) 20190231866 |
 ISBN 9780778769040 (softcover) |
 ISBN 9780778768456 (hardcover) |
 ISBN 9781427124319 (HTML)
Subjects: LCSH: Sculpture—Juvenile literature. |
 LCSH: Sculpture—Technique—Juvenile literature.
Classification: LCC NB1143 .E93 2020 | DDC j730.28—dc23

Library of Congress Cataloging-in-Publication Data

Names: Ewasiuk, Sandee, author.
Title: Sculpture skills lab / Sandee Ewasiuk.
Description: New York : Crabtree Publishing Company, 2020. |
 Series: Art skills lab | Includes index.
Identifiers: LCCN 2019052920 (print) | LCCN 2019052921 (ebook)
 ISBN 9780778768456 (hardcover) |
 ISBN 9780778769040 (paperback) |
 ISBN 9781427124319 (ebook)
Subjects: LCSH: Sculpture--Technique--Juvenile literature.
Classification: LCC NB1170 .E93 2020 (print) |
 LCC NB1170 (ebook) | DDC 730.2--dc23
LC record available at https://lccn.loc.gov/2019052920
LC ebook record available at https://lccn.loc.gov/2019052921

Crabtree Publishing Company

www.crabtreebooks.com 1-800-387-7650

Printed in the U.S.A./032020/CG20200127

**Published in Canada
Crabtree Publishing**
616 Welland Ave.
St. Catharines, Ontario
L2M 5V6

**Published in the United States
Crabtree Publishing**
PMB 59051
350 Fifth Avenue, 59th Floor
New York, New York 10118

**Published in the United Kingdom
Crabtree Publishing**
Maritime House
Basin Road North, Hove
BN41 1WR

**Published in Australia
Crabtree Publishing**
Unit 3 – 5 Currumbin Court
Capalaba
QLD 4157

CONTENTS

GET INTO SCULPTURE

Approach this book with a sense of adventure! It is designed to unleash the creativity that exists within you! The projects in this book will help you express your feelings, your thoughts, and your ideas through your art. Create images of things you want to say, or messages you want to share. When learning to make sculptures, enjoy the process and don't worry too much about the finished product. To make it easier, all the clay projects in this book can be created without a **kiln**. Find your own individual style and run with it!

WHAT IS SCULPTURE?

A sculpture is an artwork that has three **dimensions**, which means that it has height, width, and depth. It can stand alone or simply stand out from a background. Either way, it is still a sculpture. People have been making sculptures for more than 230,000 years. Clay, metal, wood, rocks, and even found objects can be used to make a sculpture. It can be made as small as a coffee mug or as large as a giant sculpture in a public plaza.

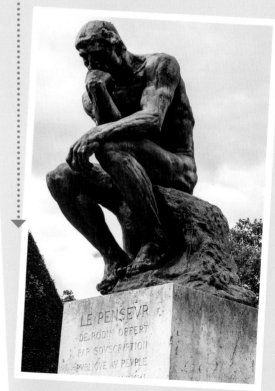

The Thinker by French sculptor Auguste Rodin (1840-1917) is one of the most famous statues ever created. There are more than 20 giant **casts** of *The Thinker* in public spaces worldwide, as well as many smaller versions. The very first cast is found in Paris.

MINI-BIOGRAPHIES

Throughout the book you will find mini-biographies highlighting the work of well-known artists. We can learn a great deal about sculpture by looking at great works of art. Experiment with the **techniques** they used. Examine the artworks to see how they were composed, or arranged. Then add your own touch to create your own art.

MAIN TYPES OF SCULPTURE METHODS

Sculptures can be created using these different methods:

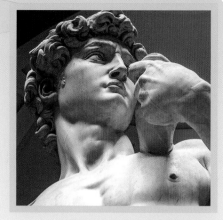

David, carved in marble between 1501 and 1504 by Italian artist Michelangelo

CARVING

Carving is the oldest known type of sculpture. The artist uses tools to take away layers from a hard material such as wood or stone. This can be done by scraping, chiseling, or cutting. It is called a subtractive process because material is taken away.

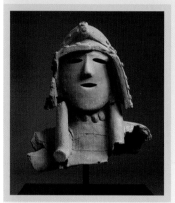

MODELING

In modeling, an artist builds up layers of a soft substance, such as clay or wax, to create a shape or form. This is an easy way to start sculpting because you don't have to cut or scrape away at a hard material. Modeling is called an additive process.

Clay warrior **bust**, early sixth century, Japan

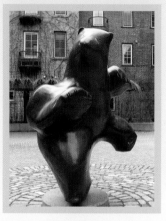

Dancing Bear, created in bronze in 1999 by Pauta Saila, an Inuit artist from Nunavut in Canada

CASTING

Casting is a multi-part process. First, an artist models a form or shape using clay, wax, or plaster. A **mold** is then made from the model. The mold is filled with a molten material such as metal or plastic which hardens, creating a cast. Molds can be used to make multiple casts, called editions, of a single artwork.

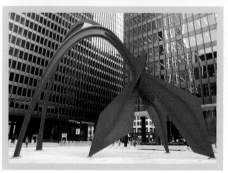

CONSTRUCTION OR ASSEMBLAGE

Construction became a major form of sculpture in the 20th century. It is also called assemblage from its French name. Artists choose from all kinds of materials and found objects, then put them together using **welding**, bolting, sewing, weaving, tying, or even plain old glue.

Flamingo, 1973, created by Alexander Calder from steel and glass for a public square in Chicago

EARTHWORK OR LAND ART

For earthwork or land art, natural materials, such as rocks and twigs, are placed into a design right on the ground. Ancient peoples created many earthworks. Land art became popular again in the 1960s.

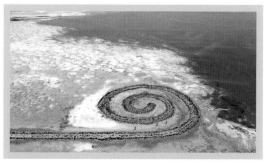

Spiral Jetty, 1970, an earthwork by Robert Smithson, Great Salt Lake in Utah

MATERIALS AND TECHNIQUES

Air-drying clay and paper-mache are used for many of the projects in this book. Air-drying clay feels like regular clay and can be molded in the same way, but does not need to be **fired** in a kiln. It dries on its own in about a day. Paper-mache is traditionally made with flour and water, but it also can be made with a water and glue mixture that's not prone to mold or being eaten by critters.

When working with clay or paper-mache, a base or supporting structure is usually created first. It can be made of wire or something solid. Then the clay or paper-mache is laid on top. The base is called an **armature**.

Tip
Throw leftover clay in the garbage and wipe your hands well before washing them off. Clay can harden in drains!

Air-drying clay comes in white, gray, and reddish colors.

Use lightweight aluminum craft wire for armatures. It can be cut with scissors.

Sculpting tools can be used for carving and smoothing clay. Ribbon sculpting tools are great for removing clay. You can also use a plastic knife instead.

A WORKSPACE FOR SCULPTURE

Making sculptures can be messy. Prepare a work area. Lay out newspapers, waxed paper, or a plastic tablecloth. Both air-drying and modeling clay will leave a **residue** on your hands so wash your hands well, when you finish working.

WORKING WITH CLAY

Always start by kneading the clay in your hands to warm it up and soften it. Use your fingers to squish, smooth, pinch, flatten, and poke the clay into whatever shape you want—big or small, thick or thin.

To form a ball, move your hands in a circle while pressing the clay lightly between them.

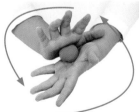

To make a slab, start with a large piece and flatten it on your work surface. Keep pressing the clay out and away from the center until it is as flat as you want it.

To make a snake shape, roll the clay on a flat surface with your fingers.

CARVING TECHNIQUES

Don't use sharp knives when learning to carve. Both clay and soap are soft enough to carve with sculpting tools or a plastic knife. When carving, always move the tool away from your body. Make sure to keep the hand holding the material away from the hand with the tool.

Carving takes patience. If you try to carve away large pieces all at once you may carve too much or the main piece may break.

When carving, use a dry paintbrush to brush away bits of soap or clay.

PAPER-MACHE TECHNIQUE

Paper-mache is made of a mixture of strips of paper and glue, or paper, flour, and water. When it dries, it becomes hard. You can make all kinds of objects with paper-mache.

Paper-mache is really easy to do. You don't need a lot of materials. Start by preparing your choice of glue and making newspaper strips. Tear the newspaper pages into strips about 1 inch (2.5 cm) wide by 4 inches (10 cm) long. Make a big pile of strips. And now the fun begins!

Before you start applying paper strips, prepare your mold and base. You can create forms from crumpled newspapers and cardboard products, or balloons.

Once your molds are ready, it is time to apply the paper strips. Cover the strips of paper with glue on both sides with a paintbrush. Then place your strips one at a time over the mold, smoothing the strips to remove any air bubbles. When it is completely dry, you can paint your sculpture.

MOLD

GLUE

PAINT

PAPER MACHE GLUE

You Will Need:

- Large mixing bowl
- 1 cup (237 mL) flour or glue
- 3 tablespoons (44 mL) salt (for flour recipe)
- Water
- Measuring cup
- Spoon

Made with Flour

Add flour and salt to a bowl and add water slowly, mixing with a spoon. Continue to add water until your paste is like a thin pancake batter, smooth with no lumps.

Made with Glue

Add 1 cup (237 ml) white glue and 1 cup (237 ml) water to a bowl. Mix together with a spoon until the mixture is well blended.

THAT'S A RELIEF

To carve a **relief** sculpture, you remove portions of clay from a solid piece of clay base. Think of your finished artwork as being inside the block of clay. The space that surrounds the carving is called **negative space**. To get your artwork out, the negative space must be removed with a sculpting tool. Depth is created by having three levels of clay: the background, the middle ground, and the foreground in front.

You Will Need:

- Rolling pin
- Air-drying clay
- Plastic knife or sculpting tool
- Paper and marker
- Pencil
- Tools for creating **texture** (toothpicks, sculpting tools, and straws)
- Optional: acrylic varnish

PROJECT GUIDES

1. Use a rolling pin to roll out a ¾ inch (1.9 cm) thick slab of clay. Use a plastic knife to cut out a tile shape and put the extra clay back in the container.

2. Cut a piece of paper the same size as your tile. Draw a flower on the paper. Place it over the tile and trace around the drawing with the pencil. This will make a slight indentation on the clay. Remove the paper.

3. Use a sculpting tool or plastic knife to make the slight indentation deeper.

4. Use a sculpting tool or plastic knife to remove the clay surrounding the drawing, leaving about ¼ inch (0.6 cm) of the clay slab. This will be the background and the lowest level of clay.

5. Now use the sculpting tool to remove some of the clay from the petals. The petals will be the middle level. Remove more clay from the outside point and less as you get toward the center. Wet the tile with a little bit of water on your fingertips. Smooth over the petals, then mold the sides of the petals to make them more lifelike. Round the edge of the center circle but don't remove any clay from inside it. The center will be the highest level of the sculpture.

6. Add texture to the tile. Make marks using items such as toothpicks, straws, and sculpture tools. Let it dry. If you want to make it shiny, you can apply an acrylic varnish to your tile when it is completely dry..

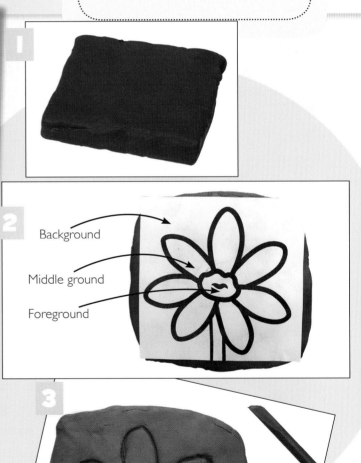

Background

Middle ground

Foreground

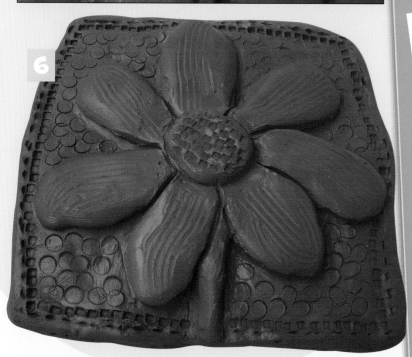

HIGH OR LOW

Relief is a way of making sculptures by carving on a flat base. The artist takes away small pieces to create a design, which can be very detailed. The base can be wood, stone, jade, or any other material that can be carved.

There are two kinds of relief: low and high. In low relief, also called bas-relief, only a small amount of the base is taken away. In high relief, or alto-relief, the carving goes deeper. A low relief looks more like a picture, while a high relief is more like a statue.

Reliefs have been found on the walls of caves of early humans, as well as in ancient and medieval cities. Today, both high and low relief remain popular. You may even find a bas-relief in your pocket—on a coin!

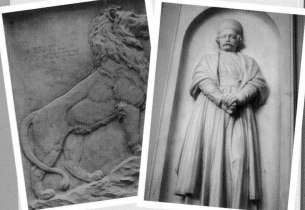

Low-relief sculpture of a lion, Illinois, early 1900s (left)

High-relief sculpture of Cowasji Jehangir by Thomas Woolner, Scotland, 1800s (right)

SOAP CARVING

In this exercise, you can **replicate** soapstone and wood carving by substituting soap for those harder materials. The technique is the same, but you don't have to use a sharp knife. Carving is a subtractive form of sculpture, just like a relief, except that the base will be carved away entirely. The sculpture is formed by removing material to develop shape and depth.

You Will Need:
- Animal photos
- Pencil and paper
- Rectangular bar of soap
- Marker
- Sculpting tool or plastic knife
- Paper clip or toothpick

PROJECT GUIDES

1. Look at some photos of animals. Choose an animal with a simple outline. A cat, fish, or turtle would work well. Make some sketches on paper. Sketch different sides to visualize all of the dimensions of the final carving.

2. Use a marker to draw the outline of the animal on the bar of soap.

3. Use the sculpting tool to start removing the soap outside of the outline. Keep removing soap until all the soap outside of the outline is gone.

4. Use the sculpting tool to go over the outline smoothing all the edges. Scrape the marker lines away with the tip of the sculpting tool.

5. Carve more soap away to form legs and other features of the animal. Create depth by subtracting soap to round edges and make indentations.

6. Use the end of a paper clip or toothpick to add fine details to the animal such as eyes, mouth, and toes. Wet your finger and rub it over the carving to smooth the surface. Let it dry.

Tip
Carve a little bit at a time to build the shape. If you break it, you can't add soap back. This is the same for stone carvers. They must work very carefully or they can ruin a large piece of stone.

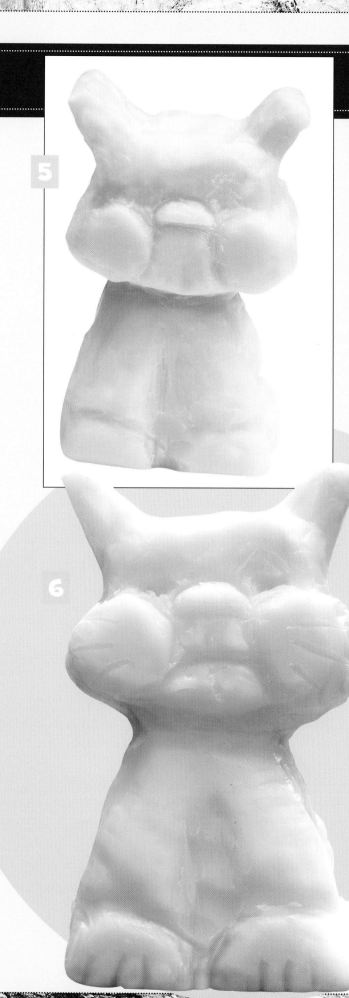

5

6

The Inuit peoples of northern Canada have been making sculptural art for more than 4,000 years. They carved walrus tusks, whale bones, and stone to decorate everyday objects and to tell the stories of their people.

Today's Inuit carvings have become an art form on their own. They are still made by hand, but not out of materials from protected species. The natural soapstone comes in colors such as black, brown, and green. The carvings are polished for hours with sandpaper.

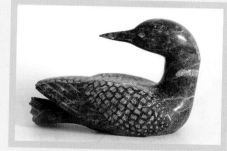

Loon (1996) by Itulu, Cape Dorset, Nunavut, Canada

Try This!

Try using a different bar of soap to carve. Soaps range from hard to soft. Each will carve differently. Experiment with different tools. Is one easier to carve than another?

ABSTRACT SHAPES

You Will Need:

- Air-drying clay
- Sculpting tools or plastic knife
- Sandpaper
- Black acrylic paint
- Metallic paint
- Rag
- Paintbrush

Abstract art is artwork in which there is no intention to represent a figure, object, or **landscape** in a realistic way. Abstract art uses shapes, colors, and lines to suggest its meaning. You can create an **organic** shape by carving a slab of clay. This will mimic the technique sculptors use to carve stone sculptures. To create visual interest try to sculpt some peek-a-boo holes to peer through.

PROJECT GUIDES

1. Set a piece of air-drying clay in the open and leave it to dry out for a day or two. Don't let it dry out completely.

2. Examine your clay and imagine a form within it. Use your sculpting tool to start removing some of the clay.

3. Continue removing more clay from the main piece of clay. Don't try to remove large chunks or it may break. Start hollowing out the peek-a-boo hole. Keep the bottom flat so it will stand and not fall over.

4. Continue carving until you are happy with the look of the sculpture.

5. Let it dry for several days or more. You can sand the dried clay with sandpaper to smooth the surface.

6. Make your sculpture look like it was created from stone. Paint the sculpture with black paint. Let it dry. Paint the sculpture with metallic paint. Rub the metallic paint with a small rag to remove some of the paint and let some of the black paint show through.

"You can't look at a sculpture if you are going to stand stiff as a ram rod and stare at it. With a sculpture, you must walk around it, bend towards it, touch it and walk away from it."
—Barbara Hepworth

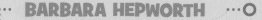

BARBARA HEPWORTH

(1903–1975) England

Barbara Hepworth was a pioneer in the field of sculpture. She was a leader in the development of modern sculpture at a time when few women achieved success as artists. Hepworth did not make models and have assistants finish the work, as many sculptors did, even for large pieces. Instead, she carved directly on her material. She is best known for her pierced sculptures. In these works, the empty space is an important negative space element.

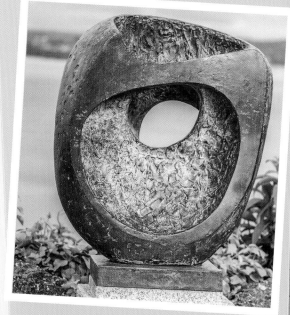

Epidauros II (1961), a bronze cast sculpture by Barbara Hepworth, in St Ives Bay, Cornwall, UK

A MODEL FIGURE

In both sculpture and painting, a semi-abstract is an artwork in which the artist creates the impression of a form but not an exact duplicate. It is **stylized** rather than realistic. However, unlike abstract art, you can still tell what the form represents. It could be an element of nature or the human figure. In an abstract, there are few or no details.

You Will Need:

- Paper and pencil
- Air-drying clay
- Small piece of wood or cardboard
- Toothpick
- Small dish of water
- Acrylic paint
- Metallic paint
- Brushes
- Glue

PROJECT GUIDES

1. Have a friend form an interesting sitting or reclining pose. Sketch the basic shape. Think about the basic shapes that make up the human figure in your drawing: ovals, rectangles, balls, and tubular shapes.

2. Start molding some of the basic shapes from air-drying clay. Make a **torso**, head, neck, arms, legs, and feet

3. Place the torso shape on your wood or cardboard base.

4. Prepare to add the legs and feet to the torso. Before attaching them, score, or draw lines, with a toothpick to create a rough edge at the point where they will be joined. Score the torso as well.

5. Wet the clay on the torso shape with a wet fingertip. Press the scored end of the leg to the torso shape. Wet your finger in the water and smooth the edges where you joined the two pieces. Join the other leg and the feet.

6. Use the same method to join the neck and head. Attach the arms. Mold the ends of the arms into hands. Use your wet finger to smooth and mold the clay until you are happy with the sculpture. Let it dry.

7. Lift the sculpture from the base. Paint the base with dark paint. Paint the sculpture with metallic paint. Let it dry. Glue the sculpture to the base.

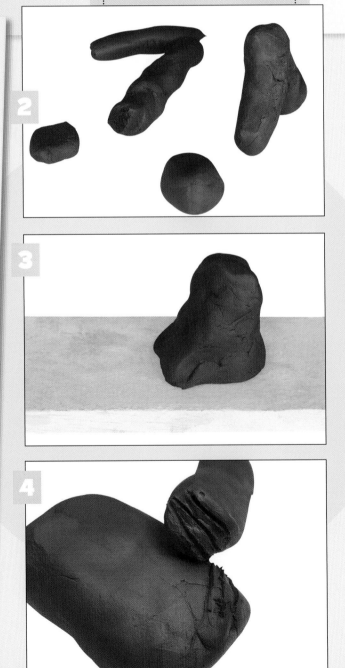

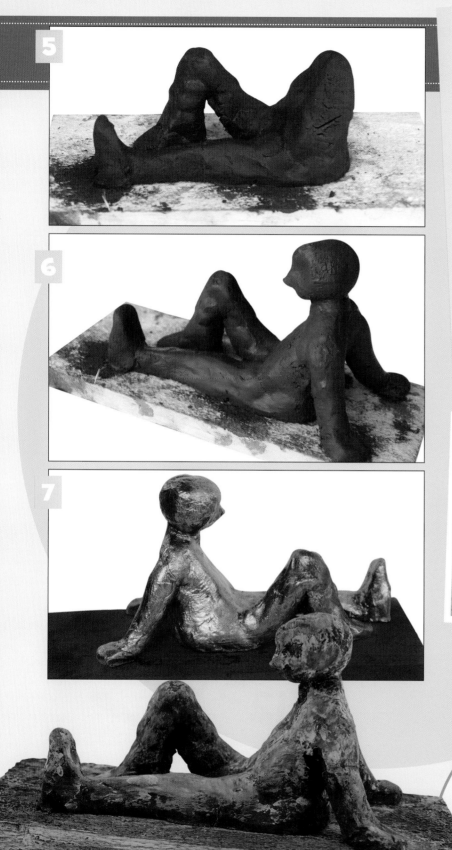

5

6

7

"A sculptor is a person who is interested in the shape of things, a poet in words, a musician by sounds."
—Henry Moore

(1898–1986) England

Henry Moore was one of the most important sculptors of the 1900s. He is famous for sculpting semi-abstract human forms.

His style was influenced by ancient chacmools, which are stylized sculptures of a reclining god made by the Toltecs and Mayans. Another influence was the rolling hills of the countryside where he grew up.

Moore is also famous for his public art in bronze, marble, and stone. The works are huge, but he would start out with small models to test the design.

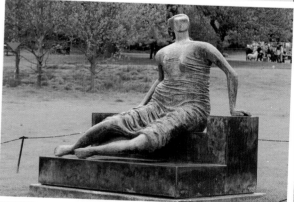

Draped Seated Woman (1957–58) by Henry Moore, in the Yorkshire Sculpture Park, West Yorkshire, UK

Try This!

Patina is a green coating that forms on bronze and copper from a chemical reaction when they are exposed to weather. Create this look by painting over the gold paint with a dark blue-green paint. Let it dry. Rub a dab of a light blue-green paint on a piece of paper towel. Rub it over the sculpture.

SCULPTURE FUN

Public sculptures are created to sit in parks or in front of buildings. So when artists choose a theme, they consider who will be passing by. Are they families, travelers, office workers? Sometimes artists use humor to convey a message. Create your own modeling-clay model of a large-scale sculpture that will make viewers stop and think about a message.

PROJECT GUIDES

1. Roll a large piece of clay in your hands, then on a flat surface to smooth it. Make a snake shape by rolling it on a flat surface with your fingers. Roll out another piece in a similar shade. Roll another in a dark color.

2. Twist the snake shape into a **spiral**. Wrap the similar shade snake around the spiral. Pinch any excess clay off with your fingers. Wrap the dark-colored snake around the spiral. Press the new shape flat and smooth the seams. This is the dial of a watch.

3. Roll out five small snake shapes in a dark color. Bend them to make the numbers 12, 3, 6, and 9. Make eight tiny lines to create hour marks. With a different color clay, roll two snake shapes. Flatten them and pinch the end of each into a point to create the hands of the watch. Roll a small ball and flatten it.

4. Press the numbers into the circle shapes. Place them as shown in the photo. Press the little lines between the numbers. Place the two hands with points away from the center. Press the circle on top of the hands in the middle of the watch dial.

5. To make the watch band, roll out two long, fat snakes in two different colors. Flatten them. Press them together. Roll out a thin snake and place it into a rectangle shape at the end of the band. Press down. Roll a tiny snake and place it in the middle of the rectangle. Use a toothpick to make holes at the other end. Make holes all along the band.

6. Place the dial in the middle of the band and press the two pieces together.

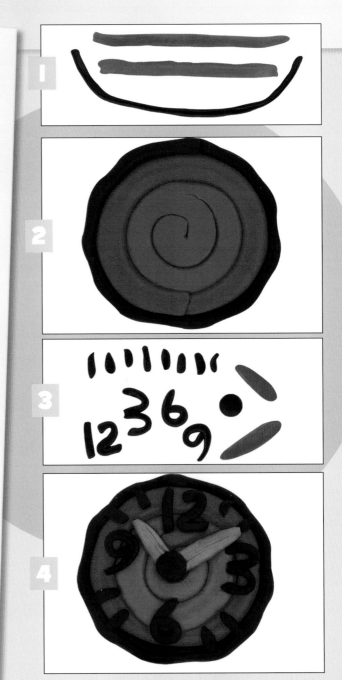

5

Try This!

Take a photo of a park or building. Take another photo of your sculpture. On a computer or tablet, cut and paste the sculpture onto the other image using a photo-editing application. The giant sculpture in a regular scene creates an interesting **juxtaposition.**

6

CLAES OLDENBURG/ COOSJE VAN BRUGGEN

(1929) Sweden/United States
(1942–2009) Netherlands/United States

Claes Oldenburg and Coosje van Bruggen teamed up to create playful public sculptures based on everyday objects such as spoons, ice cream cones, and pie. Their work is part of a movement that began in the late 1950s called Pop Art. Their giant works, called **installation art**, can be found all over the world.

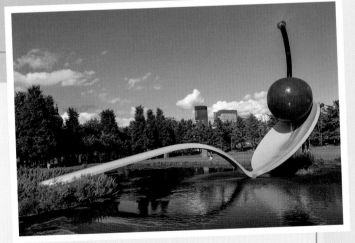

Spoon and Cherry (1988) in the Sculpture Garden of Minneapolis, MN

17

CLAY PORTRAIT

You Will Need:

- Dowel (wooden post)
- Wood board
- Newspaper
- Masking tape
- Air-drying clay
- Sculpting tools
- Paint and brushes

To sculpt a bust, or portrait, in clay, you will start by creating an armature. After adding clay to the armature, you can mold it into the shape of a head, neck, and shoulders. Use your hands and sculpting tools to add details to the face. This should be a realistic bust. Both sides of the face should look **symmetrical**. Use a photo or have someone sit for you to check for spacing.

PROJECT GUIDES

1. Have an adult create the base for the armature by nailing or screwing a dowel to a wood board.

2. Bunch up newspaper and put it around the dowel to create the armature. Use masking tape to secure it in place. Add more newspaper until you have created a head shape. Make a neck and shoulder shapes at the bottom.

3. Cover the newspaper with flat slabs of clay. Keep adding more clay until all of the armature is covered. Mold the clay into basic facial features.

4. Add more clay to create the hair, mouth, eyes, and ears. Don't forget eyebrows. Add a scarf around the neck. Pinch and mold ears at the side of the head. Add more clay for hair. When making a clay sculpture you can both add clay and subtract clay to finish your sculpture.

5. You can work on your sculpture over several days. Spray it with water to keep it moist when you are working. Cover it with plastic when you are not working on it. When you are happy with it, let it dry.

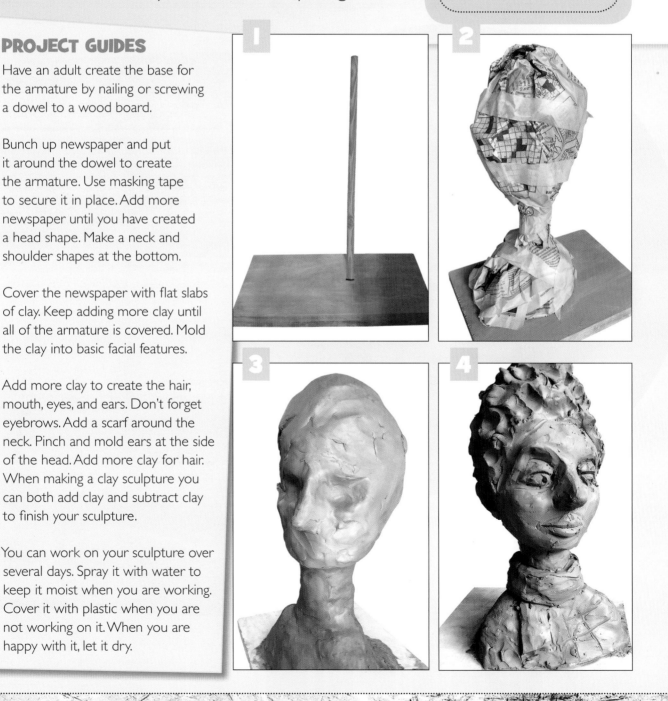

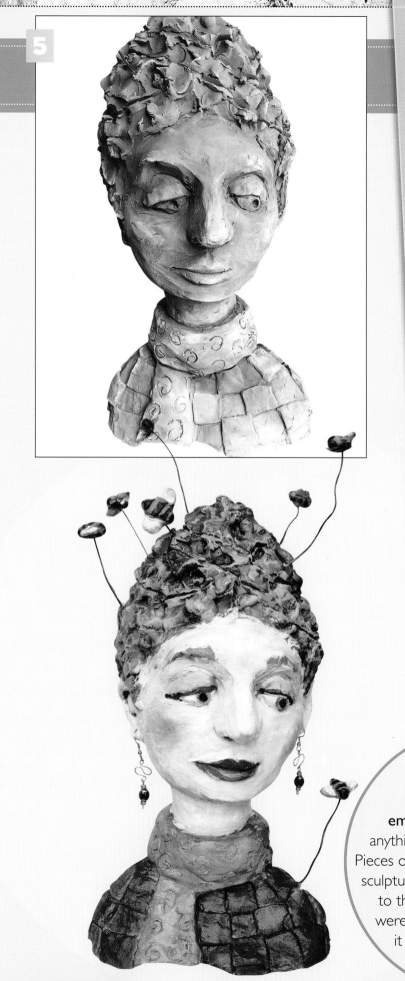

(1420–1473) Netherlands

Nikolaus Gerhaert was a famous sculptor in Europe in the 1400s. His natural style and way of expressing feeling in his artworks brought him many students and followers. He often sculpted busts in sandstone or limestone, which were painted with patina. Like most artists of his time, he created many of his works for churches and cathedrals.

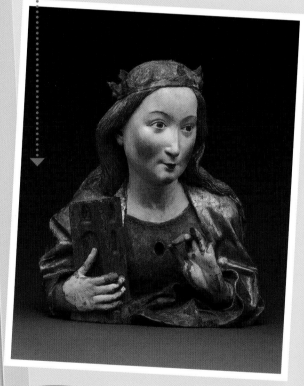

Reliquary Bust of Saint Barbara, created around 1465

Try This!

Before leaving your sculpture to dry, add **embellishments**. You can add anything that will stick into the clay. Pieces of craft wire were stuck into this sculpture. Seven clay bees were stuck to the end of the wires. Earrings were attached to the ears. When it is dry, paint the sculpture with acrylic paints.

FANTASY ANIMAL

Create a sculpture of a fantasy animal using the technique of paper-mache. You first need to make a sturdy armature for your sculpture. Balloons or plastic bottles make good bodies when building armatures. You can modify the below instructions to create any fantasy animal you can dream up.

PROJECT GUIDES

1. Choose the subject for the sculpture. You can combine two animals together or imagine something unique. Make some sketches of your fantasy animal.

2. For the body, blow up a balloon. Tear newspaper into thin strips. Prepare a container of paper-mache glue (see page 7). Dip a strip into the glue, then use your fingers to squeeze off the extra glue. Wrap the strip around the bottom of the balloon bird. Continue dipping the strips and wrapping them around your bird's body until the entire balloon is covered. Make sure to overlap and change directions of the strips as you work. Smooth the surface with your hands to make sure there are no air bubbles. Let it dry.

3. Think about what pieces you will need to make for the armature of your animal. In this example, there are three legs, two wings, one beak, and one ridge. Draw them on thin cardboard. Cut them out. Make the legs sturdier by rolling or folding the cardboard. Tape in place.

4. Tape the two wings to the sides of the balloon. Tape the ridge to the top. Tape the legs to the bottom, and tape the beak to the front.

5. Using the same method as in step 2, cover the additional parts of the animal in paper-mache. Let it dry.

6. Paint the entire animal with white paint. Let it dry.

7. Paint your sculpture. Let it dry.

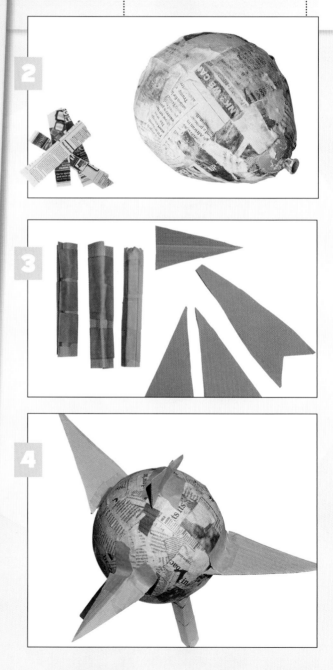

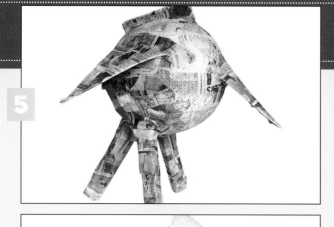

5

6

7

NIKI DE SAINT PHALLE ·O

(1930-2002) France/United States

Niki de Saint Phalle was a painter, fabric artist, and sculptor. She was also a model and perfume maker! She often explored serious issues such as women's rights, but her art could be very playful. She used bright primary colors. Her large-scale installations are made from steel and reinforced plastic. She and artist Jean Tinguely worked together to create an installation called *Stravinsky Fountain*. Made of 16 sculptures that move and spray water, the work celebrates the music of composer Igor Stravinsky.

Stravinsky Fountain (1982), Paris

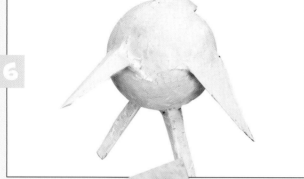

Try This!

With a group of friends, create installation art by making a big fantasy animal sculpture. Make a small model and then work together to make a big armature. Make flour-and-water paste in a large roasting pan, and use large strips of paper to cover the armature.

TEXTURAL HAND

Many sculptures are smooth in texture, but some artists use rough and jagged textures to help get their ideas across. The entire human figure is a common subject for artists, but what happens if you focus on one small part of the human body, such as a hand? Can you show emotion with just a hand? Adding texture gives it an alien feeling.

You Will Need:

- Craft wire
- Mason jar lid
- Gauze bandages
- Scissors
- Paper-mache glue
- Large stone
- Acrylic paint
- Brush

PROJECT GUIDES

1. Bend a 40-inch (102-cm) long wire into a hand shape. Start at the base by the little finger. Bend the wire at the tip of the finger. Then, twist the wire back down and continue with the next finger. After you reach the thumb, make a large loop for the palm. Wrap the remaining wire back and forth across the palm, leaving two end pieces at the bottom. Wrap the end pieces around a Mason jar lid.

2. Cut gauze bandages into strips. Prepare paper-mache glue (see page 7).

3. Dip a strip of gauze into the paper-mache glue. Remove excess glue from the gauze with your fingers. Wrap it over the wire armature. Continue adding strips over the armature. When completely covered, let it dry.

4. To balance the heavy top of the sculpture, add a large stone to the base.

5. Paint the entire sculpture with rust-colored acrylic paint. Let it dry. Use black paint on top of some of the wrinkles to **emphasize** the texture.

Try This!
Could you make the same texture with clay? Experiment by doing the same project with clay. Experiment with different tools to create texture.

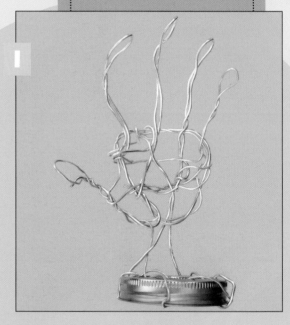

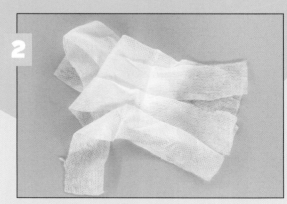

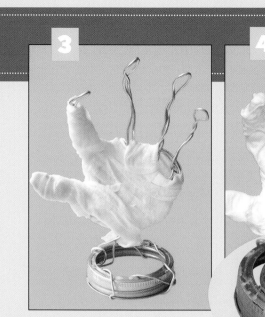

3

4

5

(1930-2017) Poland

Magdalena Abakanowicz lived through the harsh rule of both Nazi Germany and the Soviet Union over her native Poland. Her sculptures reflect that harshness but also show that people can move on together. "Art does not solve problems, but makes us aware of their existence," she explained.

She was a painter, fabric sculptor, and creator of large public installations. *Agora*, an installation in Chicago, is a good example of her style. Though the 106 cast-iron figures have no faces, each one was created as an individual with different details. The surface was textured to feel like tree bark to link them to nature.

Abakanowicz became one of Poland's most famous artists and was honored all over the world.

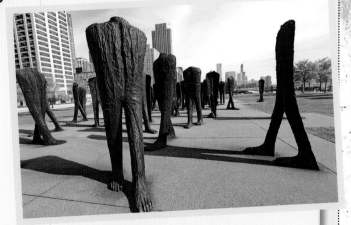

Agora (2004–2006), by Magdalena Abakanowicz, in Grant Park in Chicago

23

CARDBOARD GARDEN

Many sculptures are organic, meaning they take a natural form full of curves and smooth surfaces. You can also make a sculpture from **geometric** shapes. Try this construction type of sculpture made from cardboard shapes. Some sculptures are made into statues. To do this, the artist would create a small model, like the one on these pages. The large version would then be made out of steel and painted.

You Will Need:

- Thin cardboard
- Scissors
- Glue
- Small box
- Acrylic or tempera paint
- Brushes

PROJECT GUIDES

1. Cut five flower stems from thin cardboard.

2. Cut an assortment of triangles from thin cardboard. You will need between five and seven of these triangle petals for each flower.

3. Cut five squares for flower centers and some long, thin triangles for leaves.

4. Glue between five and seven petals to the top of one stem. Glue a square in the center of the petals. Glue two leaves to the back of the stem just below the petals. Continue until you have glued all five flowers.

5. Turn your box upside down. Make five slits in the bottom of the box by pushing the ends of a pair of scissors through the box. (Ask an adult for help.)

6. Paint the flowers, stems, and leaves white. Push the stems through the slits in the box and leave them to dry.

7. Paint all the flowers, stems, leaves, and box with bright colors. Let them dry.

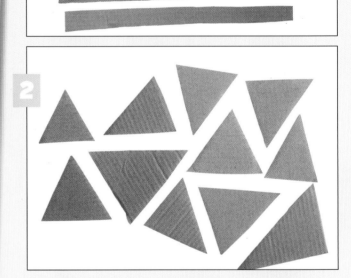

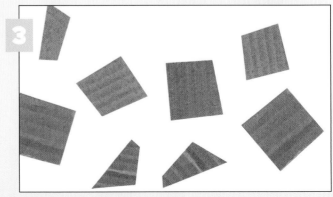

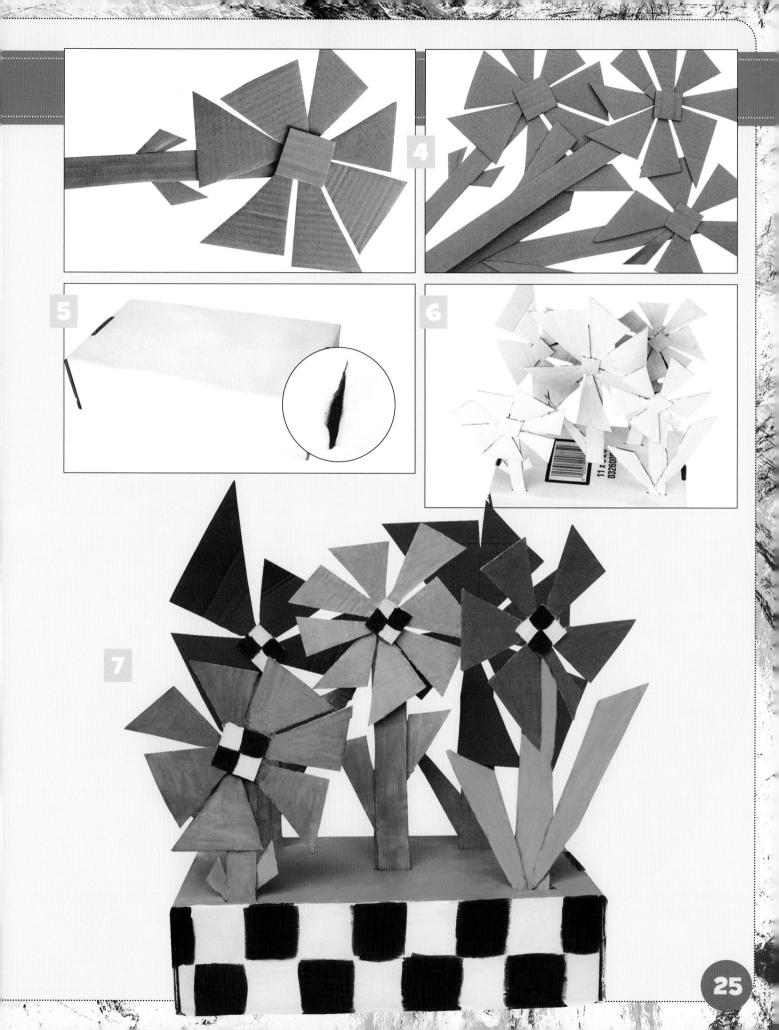

JUNK ASSEMBLY

Artists can create art from any materials. When sculptures are built from assorted materials they are called assemblages. Try creating a figure using found objects from around the house, such as plastic bottles, plastic bags, plastic packaging, and assorted junk. Assemblage art is often made to show ideas.

You Will Need:

- Assorted junk, garbage, recyclables
- Milk jug
- Paint and brush
- Water bottle
- Rocks or hardware, pieces, such as nuts
- Glue
- Tape

PROJECT GUIDES

1 Look for objects to use in your assemblage art. A junk drawer is a great place to start. The recycling bin is another place to find objects. Look around and see what you can find. To create a figure you will need two large pieces for the head and body.

2 The head in the example is a plastic milk jug cut in half. (Ask an adult to cut the jug in half.) Paint the jug with white paint. The paint will crackle and create an interesting texture. Let it dry.

3 The body in the example is a large water bottle. In order to support the weight of the head, fill it up with something heavy. Gather rocks or, as in the example here, some unused hardware pieces.

4 Glue face parts to the head. In the example there is wire chain, hardware parts, and old keys. The hair is made from a fringed strip of plastic packaging.

5 Fill the rest of the body with plastic packaging and other materials. Cut them into smaller pieces to fit them in the bottle. Glue arms and legs to the body.

6 Attach the head to the body. Apply glue around the mouth of the bottle. Press the milk jug head to the bottle. To further secure it, wrap tape around the joined pieces.

Tip

You can use regular glue for this project. Use blobs of it rather than a little drop. A low-temperature glue gun would work very well for this project, too.

4

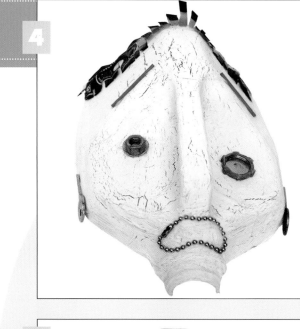

5

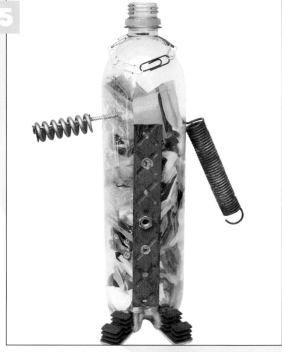

6

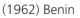

ROMUALD HAZOUMÈ

(1962) Benin

Romuald Hazoumè's art looks clever and humorous, but there is a deeper meaning behind the masks and other sculptures. Hazoumè uses his sculptural art to consider issues such as injustice and to portray life today in his native Africa. Many of his works are based on gasoline cans, which draw attention to the problem of fuel shortages and smuggling.

Plastic mask (1992-1994)

LAND ART

Sculptures made outside from natural objects found nearby are called land art or environmental sculptures. Try creating your own land art by making one or all of these examples. Leave the sculpture where you created it for others to enjoy. Over time the weather may ruin the sculpture or it may stay as it is for a long time.

PROJECT GUIDES

1 Choose a location to make your sculpture. It could be in your back yard, on a public beach, in a forest, or in a park depending on where you live.

2 Look around for natural materials to make the sculpture with. Take inspiration from your surroundings. Don't take anything living, only use items you find on the ground. Gather your materials.

3 Choose the spot to build your sculpture. Don't use any additional materials like glue or string, only what you have found in nature. If you are using rocks, you can try balancing them on top of each other. You can make a big sculpture or a small one. When you are finished take a photo of your sculpture. Then, leave the sculpture where it is.

4 Make a spiral sculpture. Try using pine cones and petals.

5 Make a sculpture out of twigs and leaves. Find an interesting forked twig or bend a twig into an interesting shape. Place the leaves through the twig.

6 Combine shells, rocks, and moss in a **concentric** circle pattern.

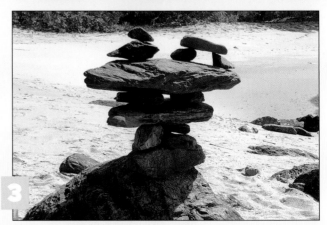

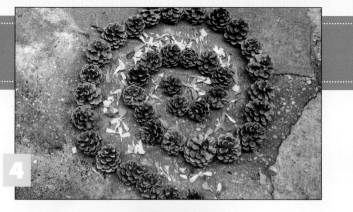

4

5

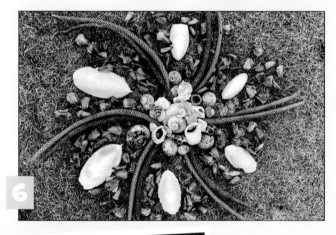

6

(1956) England

Andy Goldsworthy creates sculpture using his hands and natural materials—sometimes even ice and snow! He knows that his works often are temporary, so he records them using another art: photography. Then he publishes the photos in his books.

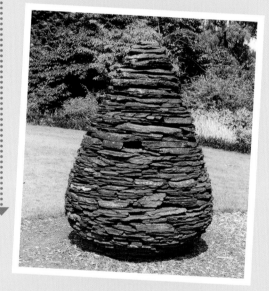

Cone sculpture (1990), Royal Botanic Garden in Edinburgh, Scotland

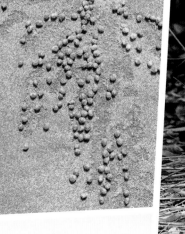

Did You Know?

Animals sometimes create art, though not on purpose! Sand bubbler crabs eat plankton and debris by filtering sand through their mouthparts. The sand comes back out in the form of balls, which look like beach art. Male bowerbirds build elaborate structures to attract a mate. They decorate with shells, acorns, moss, fruits, and flowers. If an item is disturbed, the male will put it back exactly the way it was.

Books

Alexander, Heather. *A Child's Introduction to Art: The World's Greatest Paintings and Sculptures*. Black Dog & Leventhal Publishers, 2014.

Pitamic, Maja and Laidlaw, Jill. *Three-Dimensional Art Adventures*. Chicago Review Press, 2016.

Stephens, Cassie. *Clay Lab for Kids*. Quarry Books, 2017.

Wenzel, Angela. *13 Sculptures Children Should Know*. Prestel Publishing, 2010.

Websites

National Gallery of Art
www.nga.gov/education/kids.html

NGAkids Art Zone includes descriptions of interactive art-making tools that are free to download. You can also explore the collection of the National Gallery.

Tate Gallery
www.tate.org.uk/kids

There are videos, games and activities, and projects all created to help you explore, understand, and create art.

Top 5 Sculptures
www.tate.org.uk/kids/explore/top-5/top-5-sculptures

A great introduction to sculpture as well as a wonderful collection of quizzes, art activities, and artist bios.

Everything You Ever Wanted to Know About Clay
https://kinderart.com/art-lessons/sculpture/about-clay/
This website features tools and techniques for working with clay.

GLOSSARY

abstract art Art made from lines, shapes, and colors that does not represent an actual form but suggests emotion

armature Framework for a sculpture

bust Sculpture of a head and neck

cast Object formed from a mold

concentric Circles sharing the same center

dimension A measurable distance, such as height, width, and depth

embellishment An added decoration

emphasize To make something stand out or show it is important

fired Baked in a high-temperature oven

geometric Shapes such as circles, triangles, or squares that have perfect form and don't often appear in nature

installation art A style of art that features a group of 3-D art forms in an indoor location such as a museum, mall, or library

juxtaposition When things are put side by side to compare or contrast them

kiln A large, hot oven that is used to fire the clay

landscape A painting or photo where the subject is nature, usually mountains, forests, oceans, lakes, rivers, trees, and valleys

mold A container that can be filled with a liquid substance which hardens into the same shape as the container

negative space Space around and between subjects of an artwork or photo

organic A word to describe shapes and forms associated with the natural world that are not geometric

relief A design that shows contrast between elements using line, color, and shading

replicate To repeat or copy something

residue What is left after something is taken apart or away

spiral Winding around a central point

stylized Created according to an artistic pattern rather than nature

symmetrical Having sides or halves that are the same

techniques The ways in which things are done to accomplish a goal

texture The way an artwork feels or appears to feel

torso Central part of the human body, not including the head, arms, and legs

weld To join metals by heating so they flow together

INDEX

ABOUT THE AUTHOR

Sandee Ewasiuk is a graduate of OCAD. She has participated in many group and solo exhibitions and her paintings can be found in corporate and private collections around the world. She currently divides her time between painting and teaching art at the Dundas Valley School of Art, The Art Gallery of Burlington, and Fleming College/Halliburton School of Art. She recently spent a month in Thailand as an artist-in-residence, exploring painting and mixed media. Sandee continues to experiment with and explore new ideas and techniques.